Inside **Out**

Contemporary Japanese Photography

An Exhibition of Five Japanese Photographers

Miyako Ishiuchi
Ken Matsubara
Yasumasa Morimura
Toshio Shibata
Hiroshi Sugimoto

The Light Factory Photographic Arts Center
Charlotte

This catalog was published by The Light Factory Photographic Arts Center, Charlotte, North Carolina, in conjunction the exhibition INSIDE OUT: Contemporary Japanese Photography.

Funding for this catalog was generously provided by The Andy Warhol Foundation for the Visual Arts, Inc. The exhibition was funded in part by a grant from the North Carolina Arts Council, a state agency.

The Light Factory is a non-profit photographic arts center supported by the National Endowment for the Arts, the North Carolina Arts Council, the Charlotte-Mecklenburg Arts and Science Council and our members and friends.

Distributed by **RAM•USA**
Santa Monica, California and Tokyo, Japan

Catalog design by Emily Blanchard
Printing by Classic Graphics

Cover: Yasumasa Morimura, *Doublonnage (Portrait B)*, 1988,
Courtesy of Fay Gold Gallery, Atlanta

Exhibition Schedule

The Light Factory Photographic Arts Center
Charlotte, North Carolina
September 9 through October 8, 1994

The Kemper Museum of Contemporary Art & Design
Kansas City Art Institute
Kansas City, Missouri
December 18, 1994 through February 28, 1995

Acknowledgements

Distanced by vast oceans, language and cultural barriers, American knowledge of Japan is limited. Along with our love of Japanese cuisine, we envy and admire Japan's technological wizardry and progressive management techniques. Our encounters with Japanese tourists have led us to believe that the camera is as ubiquitous in their society as it is in our own. Unfortunately though, most of us know very little about what really lies in the hearts and minds of the Japanese people. If but only a glimpse, it is our hope that the insight that is embodied in this exhibition and catalog help to further the understanding necessary for a lasting relationship between our two peoples.

The Light Factory Photographic Arts Center has been in existence since 1972 as an artist-run organization. Through exhibitions, lectures, classes and workshops, The Light Factory is dedicated to stimulating dialogue about contemporary photography, related visual arts and their connection to the social, psychological, historical and political topics of our time. In keeping with The Light Factory mission, *Inside Out* furthers our organizational objectives.

This book and the accompanying exhibition could not have been accomplished without the assistance of many knowledgeable and generous people.

We would like to graciously thank The Andy Warhol Foundation for the Visual Arts for making this book possible. A special thanks is extended to Emily Todd and Pamela Clapp of the Foundation for believing in our organization.

We are very grateful for the hard work and guidance provided by Mark Richard Leach, Curator of Twentieth Century Art at the Mint Museum of Art in Charlotte who generously volunteered his time to the project. His outstanding essay that follows is an important educational document providing critical analysis of the work as well as an historical overview.

I want to extend my deepest gratitude to Assistant Director Alice Sebrell whose leadership, tireless energy and enthusiastic commitment to this project successfully propelled it through its many stages. I am also very appreciative of Nancy Stanfield, the Center's Director of Education, who gave consistent support throughout.

Our thanks are also extended to Theresa Luisotti and Maya Ishiwata of RAM Distribution in Santa Monica, California and Tokyo, Japan who will distribute the catalog in Japan, the United States and Europe. Not only have they joined the project as publication distributor, but their encouragement, hard work and communication with artists in Japan were invaluable to us.

Sincere gratitude is due to Emily Blanchard who designed this catalog with great sensitivity to the Japanese culture, allowing the work to speak for itself.

Galleries and staff to whom we owe thanks for supporting this project include Fay Gold of Fay Gold Gallery, Atlanta, Georgia. The following New York galleries and individuals also assisted in the project's development: Jayne H. Baum of Jayne H. Baum Gallery; Roland Augustine and Lauren Wittels of Luhring Augustine Gallery; and Antonio Homem and Lawrence Beck of Sonnabend Gallery.

We also acknowledge the early support of Dr. Barbara J. Bloemink, Kemper Curator of the Kemper Museum of Contemporary Art and Design in Kansas City who, on behalf of her institution, has agreed to host the exhibition following its presentation in Charlotte.

We are very grateful to the North Carolina Arts Council for their support of this exhibition and to Okuma America for their patronage.

Special thanks to Classic Graphics. Their superior technical expertise has resulted in a professional and stunning catalog.

Also, a special thanks to Jack Kehoe, Chairman of The Light Factory Board of Directors whose leadership has always carefully guided us and to the Trustees whose good counsel and enduring support sustain the organization.

Finally, we extend our deepest gratitude to the artists whose lives are committed to the pursuit of wisdom and understanding. This project would not exist without them: Miyako Ishiuchi, Ken Matsubara, Yasumasa Morimura, Toshio Shibata and Hiroshi Sugimoto.

Linda Foard
Executive Director

3

For my children, Andrew and Aryn,
whose presence reminds me daily of my obligation
to labor for a better global tomorrow.

MRL

Origins? Quotations? Translations? A Westerner's Meditations on Contemporary Japanese Photography

If history has no goal, then there can be no basis on which to claim that one culture is more advanced toward the goal than any other. Suddenly, each culture is simply the most advanced example of its type. Each culture has an equal claim to be just where it is.[1]

In America, the '90s have been a dynamic period for Japanese culture. Major traveling exhibitions such as *A Primal Spirit: Ten Contemporary Japanese Sculptors* and *Against Nature: Japanese Art in the Eighties* have toured the United States providing audiences and curators direct contact with recent art developments in Japan.[2] So too has an interest in Japanese photography escalated, resulting in numerous commercial gallery and museum shows in New York and elsewhere.

Inside Out: Contemporary Japanese Photography uses the photographs of five artists as critical lenses through which the complex nature of Japanese culture and its relationship to the West can be considered. The exhibition is not intended as an exhaustive survey of current photography in Japan. Nor should the combination of subjects investigated by the artists in the exhibition be understood to constitute the whole of Japanese culture. Rather, *Inside Out* offers a first-hand opportunity to gain insight into the elaborate and distant cultural landscape of this country. Ironically, until recently, exhibitions of contemporary Japanese photography have been an exception, not the rule. It is fitting, therefore, that the American premier of *Inside Out: Contemporary Japanese Photography* should be held in the year of the twentieth anniversary of the first comprehensive exhibition of Japanese photographs to be presented in America.[3]

Nurturing appreciation in the West for Japanese photography hasn't been a particularly easy process. On top of infrequent exhibitions, published materials and exhibition catalogs, especially those produced in English, are scant. Even so, these and subsequent journal articles have borne the educational burden for public enlightenment. To compound the dilemma, Western curatorial methodology in the mid '70s privileged the concept of universality. In other words, any and all cultural forms were held accountable to quality standards devised by Western curators and scholars. Whether well-intentioned, borne of naiveté or conducted in the pursuit of Western cultural superiority, such judgments generally obscured the art work's significance and, by extension, a deeper understanding of the culture in which the artifacts were produced.

How, you might ask, can Western judgments impair our ability to learn about the unique and different qualities of others? The commentary on Japanese photography which follows is edited to illustrate how fundamental cultural differences can, if not framed accurately and fairly presented in the accompanying discourse, sow the seeds of misunderstanding. For example, contained in the 1974 catalog to *New Japanese Photography*, co-organized for the Museum of Modern Art by its previous director of photography John Szarkowski and Japanese co-curator Shoji Yamagishi, are fascinating and very different explanations for the exhibition's contents. In his introduction, Mr. Szarkowski states that his commentary should be "...taken only as the tentative suggestions of an admiring amateur."[4] Even so, his subsequent pronouncements carry the authoritarian weight of his position at the preeminent modern art museum in America: "The popular postwar enthusiasm for photography in Japan...seems to concern itself with no aesthetic theory or attitude, but with an almost undifferentiated love of the process itself, and a fascination with almost anything that it produces."

Further on he continues, "Having no clearly apparent qualitative standards, this enthusiasm is remarkably open-minded, and rejects nothing out of hand."[5] The opinion stated in a parallel introduction by Mr. Yamagishi provide an altogether different critical assessment of the exhibition. Yamagishi states, "Contemporary Japanese photographers have values which seem distinct from those of the photographers of the West. They are, for example, not particularly interested in the quality of the finished print." Further on, he explains that, "Some photographers even claim that devotion to the quality of the finished print merely restricts the actuality of photographic expression."[6]

Another interesting comparison can be made by considering how the two curators describe artist approaches to content and the range of conceptual interests addressed by the artists. For example, Mr. Szarkowski explains that, "The quality most central to recent Japanese photography is its concern for the description of immediate experience: most of these pictures impress us not as a comment on experience, or as a reconstruction of it into something more stable and lasting, but as an apparent surrogate for experience itself, put down with a surely intentional lack of reflection."[7] Mr. Yamagishi, to the contrary, observes that "Japanese photographers usually complete a project in book form, joining in series a number of photographs related by a common subject, theme, or idea. The full value or impact of such work cannot be understood if individual pictures are isolated from the series for exhibition on the walls of a museum. To do this deprives the photographs of their intended relationship to those which preceded or followed them in the series. In addition, the photographs were originally made to be reproduced in print form, in books and magazines, and not to be displayed as part of an exhibition."[8]

Any discussion or appraisal of cultural materials apart from the context in which they have been created is, at best, an imperfect enterprise. To the credit of the Museum of Modern Art and the curators involved, different, dissenting assessments were integral to the interpretation of the exhibition. And although Mr. Szarkowski acknowledges his limitations, nonetheless, his viewpoint remains staunchly Western. These differing opinions illustrate fundamentally contrary cultural values and opinions that can be a worthwhile lesson for students of global culture. Two decades later, much has changed. Curators acknowledge their biases and limitations but many also endeavor to be truthful to historical and contextual circumstances. The exhibition at hand is no less fraught with interpretive challenges than the one described above. That American educational and cultural institutions now consider a global perspective essential to the conditions under which culture is studied and interpreted signals, at least tentatively, that an ecumenical playing field is emerging.

Inside Out: Contemporary Japanese Photography presents the pictures of Miyako Ishiuchi, Ken Matsubara, Yasumasa Morimura, Toshio Shibata and Hiroshi Sugimoto. Wherever possible, each artist has been represented in-depth to underscore context, continuity, innovation and subtlety. Geographical distance precluded sustained dialogue between the organizers and the artists. Thus, the artist's representatives in Japan and America became crucial facilitators in the curatorial selection process. In several cases, artist/curator exchanges regarding the selection of exhibition photographs, particularly where the series concept is concerned (Shibata and Sugimoto), reiterated historical findings discussed above.

The subjects the artists *Inside Out* features are as diverse as Japanese culture is complex. Although it is difficult to categorize the exhibited work in meaningful ways, the most mutable, recurring motif is that of landscape. Its expression,

though, assumes many guises. For example, Toshio Shibata and Hiroshi Sugimoto engage traditional aspects of the genre, Shibata aping more to an examination of Japanese topography from a social perspective. Sugimoto, on the other hand, mines pictorialism for conceptual and philosophical purposes. Miyako Ishiuchi's compelling portraits of hands and feet embrace figuration but also play to concepts of the body as landscape. And Yasumasa Morimura, though plumbing Western art to investigate hierarchies of gender, heritage and culture, nonetheless metaphorically alludes to the shifting landscape of global culture.

Repetitive motifs are another fascinating concept that here, handled with ingenuity and intellect by Miyako Ishiuchi and Hiroshi Sugimoto, offer stunning, enthralling and in-depth discoveries. Imagine being confronted with a series of photographs whose subject is compositionally as simple as an ocean view in which the horizon line bisects the frame equally; the sky above, the water below. Or consider a large photographic sequence of human feet and hands. How remarkable can either subject be? What can they possibly reveal about the landscape or the sitter? In both cases, the subjects resonance festers like an infected wound untreated or like a snowball, rolling out of control downhill. They describe simple subjects in wondrous detail and disclose the essence and primal, metaphysical nature of existence.

Yasumasa Morimura and Ken Matsubara serve as director, producer, designer and, in Morimura's case, even subject, creating messages of an altogether different character. Morimura, for example, creates photographic hybrids by combining reproductions of Western master paintings and his own likeness in the subject's place. Creating richly painted backdrops against which precisely built, gilded geometric forms are posed, Matsubara's large color photographs become epiphanies of the dual worlds of

order and chaos, the rational and irrational. But while comparisons are useful in that they yield illuminating departures in subject and technique, a close, careful study of a single artist's work reveals the dense, rich creative vision of the artist.

1947 is, in and of itself, potentially insignificant to most, cryptic to some, enlightening, even unsettling to others, still nostalgic for a great many more of us. For Miyako Ishiuchi, 1947 is the year of her birth. *1 • 9 • 4 • 7* is also the title of a stunning series of portraits that are unlike any we have seen previously. For Ishiuchi's likenesses are not those stereotypic human facades generally synonymous with the portrait genre but those of body parts little thought of when the concept of personal identity arises. No, these effigies at first glance, are the ordinary, anonymous body parts called hands and feet. What makes them all the more compelling, considering Japan's patriarchal culture, is that the hands and feet that Ishiuchi memorializes are those of women born in the same year as the artist. Ishiuchi explains, "The reason why I wanted to take these photographs was simply because I was born in the year 1947. There is nothing particularly special about 1947; it is purely coincidental that it happens to be the year when I was born. And it also happens that I've turned forty years old. Again, there is nothing special about turning forty; it just happened that after turning forty, I came to have the desire to meet women my own age."[9]

The titles of Ishiuchi's subjects are simple, describing each woman's occupation. But not only are the pictures' titles revealing in the vocational descriptions they provide. When contemplated as a whole, they also disclose a culture in transition. Where "housewife" was previously the archetypal role of Japanese women, the titles suggest that these circumstances are changing. Among the diverse women's vocations the artist's pictures highlight are office worker, finance company employee, association

member, painter, part-time worker, Shinto instructor, physician, music instructor and columnist. Even though the status of women in Japan is changing, according to one female Japanese observer of Ishiuchi's *1 • 9 • 4 • 7* series, "Even today, women are expected to be silent partners and to keep their opinions to themselves. When I look at these pictures, I hear their thoughts and feelings clearly. It is here that our silent concerns are rendered visible."[10]

While Ishiuchi's pictures of women's hands and feet do contain gender-related narratives, they also possess qualities of a universal nature. The human prototype, for example, is ideally born with hands and feet, and everyone ages. Ishiuchi's photographs heighten our awareness of the aging process. In vivid detail, the artist's photographs reveal fascinating and quite odd features: peculiar toenail manifestations, dizzying skin patterns, irregular bone structures, seemingly translucent and opaque skin, unusual disfigurements and much more. Physical aging notwithstanding, the artist also sees in these pictures a form of spiritual enlightenment. According to Ishiuchi, "The clock of time continues to steadily proceed after forty. Three years older. Five years older. Ten years older. Then the day comes when the body itself disappears. As I let these thoughts flow through my mind, I find myself continually in awe of time, and I feel that my existence, which completely covers my physical body, is quietly set free in the midst of these photographs."[11] The artist also believes that feet can describe a person's humanity, stating "I never thought that it would be so thrilling to discover the beauty, the dignity and the wonderful charm that the feet contained. I felt that in the feet, precisely because they stubbornly tread the earth while all along supporting the rest of the body, was where one's true character lay hidden."[12]

One apprehension that nags curators and cultural historians, particularly in the global culture context, is the fear of not knowing the origins of cultural materials or of misattributing an art work by tracing it to one author or culture instead of another. A prophetic observation made by Mr. Szarkowski twenty years ago, which still resonates today, is his assertion that the global transmission of ideas will result in a homogenous style, thereby rendering cultural origins indiscernible. According to Szarkowski, "The formal and technical vocabulary of the arts has been universalized by photomechanical reproduction...what comes new from an artist today will, if interesting, be the common property of the whole world next year, though perhaps in a form slightly damaged in transit."[13]

Ken Matsubara's photographs are an amalgam of sculpture, painting and photography. All the elements which comprise his work are organized and presented in such a way as to have prompted one American critic to include Matsubara, among other Japanese photographers, in the following statement: "Without suggesting that these photographers' output lacks qualities that are inherently Japanese or that it has been in any deliberate way westernized (even if unconsciously), it is safe to say that, unless one knows their names and nationalities before seeing their pictures, one would not assume their imagery to be Japanese in origin; it seems to come from an international field of ideas."[14] What Coleman obliquely and, subsequently, a Japanese curator are specifically referring to in Matsubara's photographs is the appearance of a relationship between the artist's work and "...styles from Abstract Expressionism to Minimalism."[15] This observation, however, illustrates how Western cultural dogma can have debilitating, almost amnesia-like effects where global cultural discourse is concerned. Imagine the stunning traditions of Japanese scroll painting, architecture and landscape architecture, art forms inherent to Matsubara's own heritage not having occurred to either observer and thus having being completely

excluded from a discussion of his pictures! More important is the Japanese curator's inference that Matsubara's proposed affiliation with American Modernism, even in the '90s, reinforces the artist's credibility and that of his work in a Japanese context. Is the intention here to suggest that by linking the artist to his own heritage is to incur a liability or that by entering into a critical discourse with his own culture, one could conclude that he is passé? Though this observer is unaware of the artist's intentions, as an artist's statement was unavailable, nonetheless the questions remain pertinent.

Matsubara's exquisitely colored, sensual and dramatically staged photographs are ironic and deceptive. To make his pictures, the artist works as designer, producer and director. The lushly painted backdrops and gilded sculptural elements that he creates himself are carefully positioned, hauntingly lit and photographed to achieve stunning perceptual ambiguities. Matsubara's synthesis of sculpture, painting and photography are a genre of photographic expression equally curious to American and European photographers.[16] Among his American contemporaries are John Pfahl, who has experimented similarly with the perceptual gaze, and numerous others for whom the art of constructing the photograph's subject is as comparable an art form as that of the completed photograph.

According to curator Kazuhiro Yamamoto, Matsubara is "...concerned with the condition of the space created by the magical medium of photography."[17] Flatness and pictorial space are photographic elements that become engaging foils for Matsubara's carefully conceived, staged environments. Gilded spiral, cube, spherical and polyhedral sculptures, whose intricate, finely crafted and precious-looking forms often contain *trompe l'œil* illusions, are precariously balanced or suspended by the artist in front of painted backdrops. Organized into a top-bottom configuration, these settings generally contain a dark

monochrome rectangle surmounted by a loosely-painted, gestural field. Although the activated, painterly surface appears spontaneous, and to some extent it genuinely is, it is, to some extent, also pre-meditated. The artist plays diagonal paint strokes against the photograph's rectangle to activate spatial perspective and the illusion of depth beyond the flat surface. Thus the push-pull tension created by the marriage of flat and illusory space complicates and confuses our perception of "photographic truth." But Matsubara's enterprise delves deeper, probing the relationship between the cognitive and metaphysical areas of human intellect by posing essential problems. How is one to reconcile the dualities of chaos and order, rational and irrational, motion and stillness, light and its absence? The artist uses the photograph to contain such fundamental opposites, elements which in theory and in the real world are tentatively and delicately joined, but in the magical, seemingly improbable world of photography, become eternally fixed, resonant conundrums.

Nowhere amongst the photographs presented in *Inside Out* does it become more apparent that what was once the West's creation of a fictional Orient, known as *Orientalism*, has been transmuted into a critically structured Occidental view than in the brilliantly conceived hybrid pictures of Yasumasa Morimura. According to art historian Norman Bryson, "Looking at Occidentalist art, Western viewers can perhaps experience some of the shock of misrecognition that an Islamic viewer might experience looking at the imaginary Orient of Ingres or Delacroix or Gérôme."[18] Morimura is part of a larger global movement that includes artists whose cultures continue to suffer the ill effects of colonialism and occupation in the postcolonial period. As described by artist and writer Coco Fusco, "The hegemony of national cultures is perpetually disrupted by 'foreign' information, media, consumer items and people."[19]

In an attempt to subvert such activities,

these artists adopt "equalizing strategies," reasserting concepts of identity and heritage oftentimes by appropriating the cultural property of their oppressors. In Morimura's ostensibly polite art historical canon, Western masterworks, which are known to the artist through photographs and reproductions in books, are rephrased to send different messages and to tell revisionist stories. A wholesale change in a painting's appearance could never carry the powerful, subversive message that do the artist's pictures. Instead, Morimura plays on the false sense of security Westerners have constructed by infiltrating and overwriting the cultural "standard" with an "undesirable" or "tainted" image. The moment of "false" identification that we experience with his altered masterpieces is the point at which Morimura has seduced viewers into his trap. By rendering the viewer vulnerable to such a ploy, the artist suggests how pervasive and insidious Western hegemony has become.

Morimura's cultural reversals are seductive, fascinating, sophisticated and enduring. Coco Fusco describes the tactic deployed by artists such as Morimura this way: "The strategy of taking elements of an established or imposed culture and throwing them back with a different set of meanings is not only key to guerrilla warfare; the tactics of reversal, recycling, and subversive montage are also aesthetics that form the basis of many twentieth-century avant-gardes."[20] Although the artist frequently uses European paintings to accomplish his objectives, his oblique and conceptually rich impersonations also investigate cultural archetypes in imaginative and meaningful ways. Curator Kathy Halbreich has noted, "Given Morimura's interest in Duchamp, the Frenchman most responsible for bringing the discourse of art into the light of life, it should be no surprise that the texture of the real world proved more compelling than pictures of the old."[21] In *Doublonnage Portrait B*, for example, which is a play

on Duchamp's earlier portrait of his feminine alter ego Rrose Sélavy, Morimura uses the respected Kabuki theater art form of female impersonation (*onnagata*) to critique Western paternalism. Cloaked in a wedding gown to symbolize virginal innocence (cultural purity), the male artist as bride has carefully gilded his face and hair obscuring his Japanese origin in an attempt to become palatable to her future husband (Western culture). Cleverly, Morimura uses the Japanese tradition of prearranged marriage as an analog and metaphor for the relationship Western hegemony has concocted for its ostensibly submissive, feminine (cultural) "other." Mozart chocolates, covered with gold wrappers just as Morimura is himself, become emblems of "high culture" and currency of the West. Alluring and momentarily capable of satisfying the West's insatiable hunger for the exotic, in the end, time and gratuitous self-satisfaction slowly eat away at the gold veneer, revealing a different truth.

Landscape is a recurrent motif in Japanese and Western art. Even so, the twentieth-century Japanese conception of the genre in photography is considerably different from that in the Western world. According to James Enyeart, "The very word 'photography' originally translated in the nineteenth century so differently between languages: for example, English (to draw with light) and Japanese (to copy nature). It is immediately apparent that the issue for Japanese photography centered on the medium's aesthetic potential in a way that was more concerned with realism than that of the Western world. For Europe and America the idea of drawing with light was from the beginning an inherent abstraction that accepted the camera's capability as a faithful witness, but an abstraction nonetheless...In Japanese photography, however, reality and not its abstraction has been the concern of its aesthetic potential from the beginning."[22]

Seductive and critical, the dualism Toshio

Shibata brings into play contrasts the changing landscape pictured beautifully against a nostalgic recollection of the primal outdoors, filtered through Japan's and the West's earlier pictorial traditions. But to understand the rich, urgent and humanistic message the artist's pictures contain, one must acknowledge Japan's circumstances. The Japanese continent is finite, renewable resources few, and the country's topography is dynamic, subject to recurrent geologic and environmental phenomena including earthquakes, typhoons and the like. Although people are everywhere present in the Japanese countryside, in Shibata's pictures humanity is frequently represented by immaculately conceived and finely crafted concrete terraces, dams and retaining structures, all designed to forestall erosion or restrain natural forces for human benefit. In an essential way, the artist's pictures betray the delicately balanced, eternal cycle of human consumption, remedial intervention/preservation and reclamation, by positing human imagination and will on the one hand against nature's anarchy on the other. The artist's pictures of these structures can also be read as potential disasters. Subtle, still and apparently quiet on the surface, Shibata's pictures possess a shrill undercurrent and foreboding. They bring us to the brink of disaster, to the moment where control and chaos collide. If they cast but a doubt on the wisdom and futility of a human contest with nature, then they have been successful in opening our minds to the possibility of failure.

One unfortunate stereotype that Shibata's pictures indirectly help to dissolve is the difference between what many in the West consider the exacting nature of Japanese culture in general and an altogether rich, ethnocentric viewpoint which privileges Japanese aesthetic holism. Art historian Donald Kuspit, for example, has observed that in Shibata's photographs, the artist infers "...the extraordinary Japanese respect for nature, but he also suggests the peculiarly ritualized–almost rigid–character of

Japanese life. He implies that for them life oscillates between organized idiosyncrasy (nature mastered) and imposed order (technology reigning).[23] Western interventions upon the unfettered outdoors often begin abruptly. Shibata's photographs, however, describe the care and sensitivity given over to transitions between the civilized and natural worlds or the brilliantly conceived but tenuous negotiations of the uncultivated landscape. Craftsmanship and artisanry reign supreme in the rural countryside that Shibata pictures. Wonderfully undulating, geometrically patterned expanses of concrete retain the topographical character of the landscape and, in a humorous and ironic twist, allude to the potential energy the earth's brittle skin possesses and these structures promise to impede. True to the form and spirit of their aesthetic heritage, the Japanese have considered how structural integrity and decorative embellishment can be allies, offering ingredients of utility and pleasure in a world that demands consumption and preservation.

Unlike the artists discussed above, all of whom reside in Japan but have visited America, Europe and presumably other global destinations, Hiroshi Sugimoto has lived in New York since 1974. Prior to taking up residence there, he studied at the Art Center College of Design in Los Angeles where he received a B.F.A. in 1972. Having studied in an American art school and having immediate access to emerging American art developments since moving to the United States, a more believable argument can be made for acculturation and for the artist expressing a more specifically American aesthetic viewpoint. However, there is equally a reason to believe that while he may have refined his vision with American avant-garde principles, we can witness in his seascapes a unique but related vision, one plumbed by other Japanese contemporaries.

Born within several years of Sugimoto and one another, Jun Morinaga and Hiroshi Yamazaki

were similarly fascinated with seascapes and different attributes of water, sky, time and photographic formalism. For Morinaga, as seen in his 1975 - 1979 series *Sea – On the Waves*, the structure and variety of waves made manifest by changing environmental circumstances and the concept of humility in confronting the water's vastness were themes expressed in his pictures. Yamazaki, however, after loosing interest in making images whose subjects included stage pictures (performance), the artist turned to a process-based strategy choosing instead, as one writer describes his *Heliography* series, to have "...captured the tracks of the sun or its reflection on the sea on film...to reveal a craving for purity of light and time."[24] Though these artists are related in that each shares the formal linkage which the series concept offers and each demonstrates their urge to explore the ocean/atmosphere dialectic, Hiroshi Sugimoto's "seascape" pictures bring into focus an altogether different approach to global landscape traditions and much more.

Sugimoto's compositions are notable for their simple, consistent format; the horizon line bisects the frame–the sky above and water below. All of his pictures offer vistas in which nothing but water and sky are the apparent themes. This repeated subject, simply expressed may initially be dismissed by the casual observer. However as curator Kerry Brougher notes, "In a world of images that demand to be read in an instant, that release all of their information in one flash of colorful insight, that are absorbed and reconfigured by consumerism, that blur the divisions between media, that, in short, cannot be trusted, Sugimoto's seascapes stop us in our impatient and skeptical tracks. For Sugimoto's photographs attempt not to define the world, but rather to reveal it slowly through patient observation and intense perception."[25] As Brougher suggests, these photographs are complex in various ways. The light conditions, for example, betray the approximate time

of day that each picture was made. A careful study of the atmosphere reveals a reciprocal effect in the water's surface. Additionally, Sugimoto's titles disclose that these pictures, perhaps to our surprise, are made at different global locations. Imagine attending to this subject in such a detailed, time-consuming and exhaustive way! Why not work as Claude Monet did when he rendered his *Rouen Cathedral* series? After all, Monet let the time of day and the attendant conditions of light articulate the material substance of the church's great stone facade.

Why would an artist persist in his pilgrimage to photograph seascapes from sites across the globe whose vistas, as the artist pictures them, are virtually indistinguishable, especially from a topographical perspective? Is it an attempt to strip away the exotic or the specific detail that renders locales individual so as to prompt an ephiphanic discovery? Is it to privilege the ordinary in what we are led to believe is the extraordinary? Or is it a quest for deeper significance hidden in the familiarity of the subject or obliquely referred to in metaphoric terms? But what if Sugimoto's impulse is rooted in his Japanese heritage? According to Japanese history professor Henry D. Smith II, "Literal-minded visitors to contemporary Tokyo may find little of relevance or appeal in the city's 'sky and water.'...But if they–really 'we,' the outside observers–look again, beyond these surface observations and quick judgments, look back through the history of the city to its Edo origins almost four centuries ago, we come to learn that 'sky' and 'water' in fact control the form and spirit of Tokyo. We discover no matter how the content of the sky and water change, their underlying deep structures persist."[26] Could Sugimoto's message be an eternal one? If we consider the different locations to which the artist has traveled in pursuit of these pictures, and having returned, his urge to share the collective fruits of his travels with us for our pleasure and enlightenment, then what greater knowledge might the artist desire for us to acquire? Perhaps Sugimoto refers to what in Japan is known as the *miegakure* ("now you see it, now you don't") aesthetic. Though it relates specifically to urban design and the atmospheric envelope's tendency to obscure and reveal the Japanese skyline, the artist may be using it here to suggest that whatever veneers or rhetoric are applied to a subject, that in the end such finishes or embellished language, when carefully considered, can be stripped away and the truth revealed.

In the end, the photographs *Inside Out: Contemporary Japanese Photography* presents, might be better understood as prisms, not lenses, through which we can survey the present state of Japanese culture. Prisms, perhaps, because they refract, or include, a more complete spectrum of colors (cultures) that comprise light (global culture) and are thus better able to describe to us the rich, multilayered composition of Japanese identity. But it didn't happen all at once. History tells us of numerous encounters between the peoples of the globe and the Japanese. As such, we might consider that today's Japan, like every culture across the globe, has evolved into an aggregate, formed over time by exposure, improvisation and adaptation. As there is continued resistance to an emerging and different historical paradigm, one which Thomas McEvilley outlines above, there will surely be struggle, conflict and negotiation. But, as Coco Fusco's observations corroborate, such exchanges can have constructive results: "...the irreverence and exuberant energy of these aesthetic strategies is evidence of the survival of subaltern practices that have created the conditions for spiritual renewal, as well as for critical reinterpretations of the world in which we live."[27]

Mark Richard Leach
Curator of Twentieth Century Art
Mint Museum of Art, Charlotte

The author wishes to thank Dr. Barbara J. Bloemink, Kemper Curator of the Kemper Museum of Contemporary Art and Design, Kansas City, Missouri for her encouragement, insight and judicious review of the manuscript.

[1]For further discussion on the detrimental effects of universal proscriptions for quality, see McEvilley, Thomas, "Appendix A: The Global Issue," in *Art & Otherness: Crisis in Cultural Identity* (New York: McPherson & Company Publishers, 1992): p. 156.

[2]For further information, see Fox, Howard N. and Toshio Hara, et.al. in *A Primal Spirit: Ten Contemporary Japanese Sculptors*, exhibition catalog (Los Angeles: Los Angeles County Museum of Art, 1990); and Halbreich, Kathy and Thomas Sokolowski, et.al. *Against Nature: Japanese Art in the Eighties*, exhibition catalog (New York and Cambridge: Grey Art Gallery and Study Center, New York University and MIT List Visual Art Center, 1989). Both exhibitions toured America in the early '90s, exposing American audiences to recent developments in Japanese art.

[3]For a complete discussion of the exhibition, see Szarkowski, John and Shoji Yamagishi in *New Japanese Photography*, exhibition catalog (New York: The Museum of Modern Art, 1974). For related commentary, see Coleman, A.D., "The East Comes West: Japanese Photography in the U.S. Today," in *Camera & Darkroom*, (June 1992): pp. 19 - 27.

[4]Op.cit.: p. 9.

[5]Op.cit.: p. 10.

[6]Op.cit.: p. 11.

[7]Op.cit.: p. 10.

[8]Op.cit.: p. 11.

[9]Ishiuchi, Miyako, "On '1947'" in *1 • 9 • 4 • 7* (Tokyo: IPC Inter Press Corporation, 1990).

[10]The author reviewed Miyako Ishiuchi's pictures with Utako Kobayashi of Niigata Prefecture while an intern at the Mint Museum of Art, Charlotte. At the time of the exchange, Ms. Kobayashi was completing a year abroad as an international student at Winthrop University in Rock Hill, South Carolina. She is currently pursuing a B.A. degree in lifelong education at Yokohama University, Japan.

[11]Ishiuchi: n.p.

[12]Ishiushi: n.p.

[13]Szarkowski, p. 9.

[14]Coleman, A.D., "Ken Matsubara: Drama of the Inanimate," in *The World & I* (October 1993): pp. 144; 146.

[15]Yamamoto, Kazuhiro, "Ken Matsubara: Gazing at Life Held Still," in *Ken Matsubara: Vertical and Horizontal*, exhibition catalog (Tokyo: PS Gallery, 1990): n.p.

[16]For additional discussion, see Weinberg, Adam D., et. al. in *Cross-References: Sculpture into Photography* (Minneapolis: The Walker Art Center, 1987).

[17]Yamamoto, n.p.

[18]For a brief and illuminating discussion on this fundamental aspect of Morimura's sensibility and Occidentalism in general, see Bryson, Norman, "Yasumasa Morimura: Mother (Judith II),' in *Artforum* vol. 32, no. 5 (January 1994): p. 71.

[19]Fusco, Coco, "Passionate Irreverance: The Cultural Politics of Identity," in *1993 Biennial Exhibition* (New York: Whitney Museum of American Art, 1993): p. 76.

[20]Op.cit.; p. 83.

[21]Halbreich, Kathy, "Yasumasa Morimura," in *Culture and Commentary: An Eighties Perspective* (Washington, D.C.: The Hirshhorn Museum and Sculpture Garden, 1990): p. 88.

[22]Enyeart, James "Traces of Splendor and Destiny," in *PHOTOGRAPHS by Toshio Shibata* (Tokyo: Asahi Shimbun Publishing Co., 1992): n.p. Enyeart's discussion of Shibata's pictures is indebted to Munesuke Mita's "Tokyo: A City Perspective." Mita's essay appeared in the exhibition catalog accompanying *Reality, Dream and Fiction: Japan, 1945 - 1990* mounted by the Tokyo Metropolitan Museum of Photography in 1990.

[23]Kuspit, Donald, "Toshio Shibata," in *Artforum* vol. 31, no. 8 (April 1993).

[24]Yokoe, Fuminori, "Hiroshi Yamazaki," in *Japanese Photography in the 1970s: Memories Frozen in Time* (Tokyo: Tokyo Metropolitan Culture Foundation and Tokyo Metropolitan Museum of Photography, 1991): p. 137.

[25]Brougher, Kerry, "Hiroshi Sugimoto: Memories in Black and White," in *Sugimoto* (Los Angeles: The Museum of Contemporary Art, 1993): n.p.

[26]For a rich and detailed discussion see Smith II, Henry D. "Sky and Water: The Deep Structures of Tokyo," in *Tokyo: Form and Spirit* exhibition catalog (Minneapolis and New York: Walker Art Center and Harry N. Abrams, Inc. Publishers, 1986): p. 21; 22 - 35.

[27]Fusco: p.85.

1947 No.9 Pub Manager

Miyako Ishiuchi

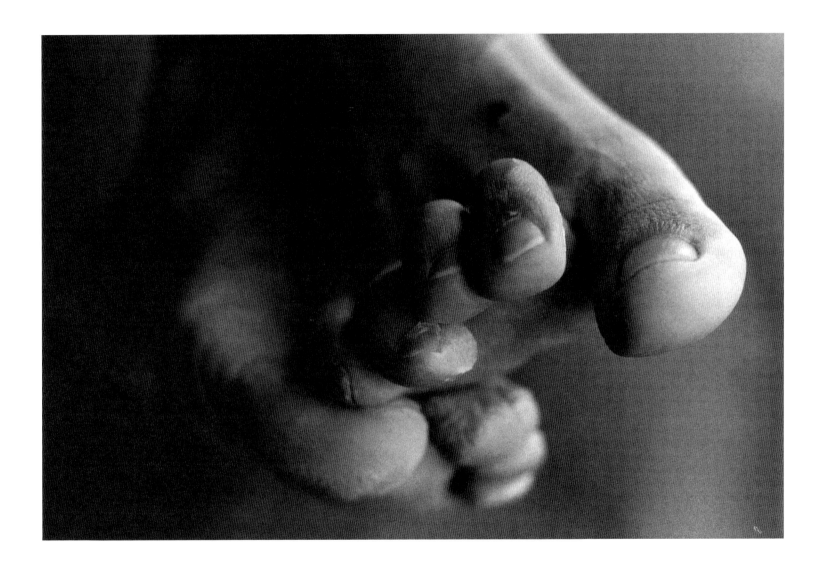

1947 No. 23 Painter

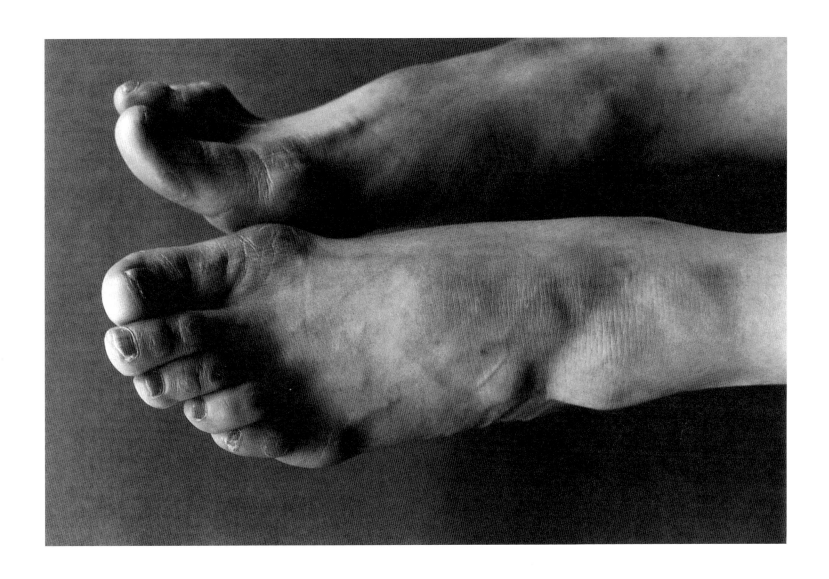

1947 No.29 Housewife

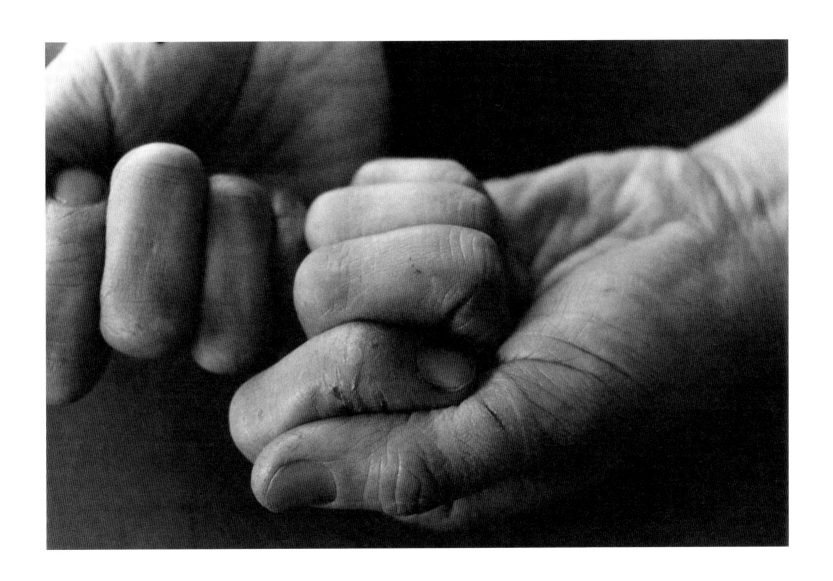

1947 No.37 Finance Company Employee

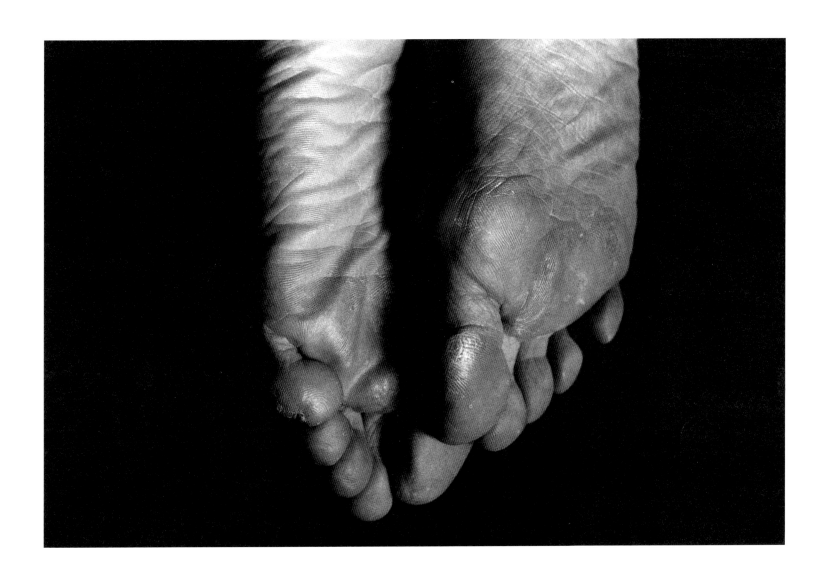

1947 No.61 Housewife

Vertical and Horizontal #10, 1990

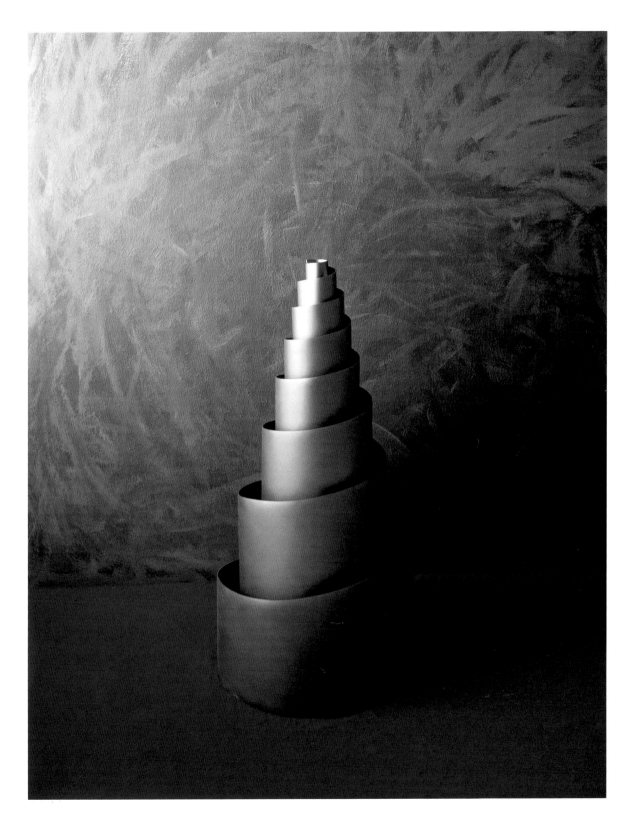

Vertical and Horizontal #15, 1990, (detail)

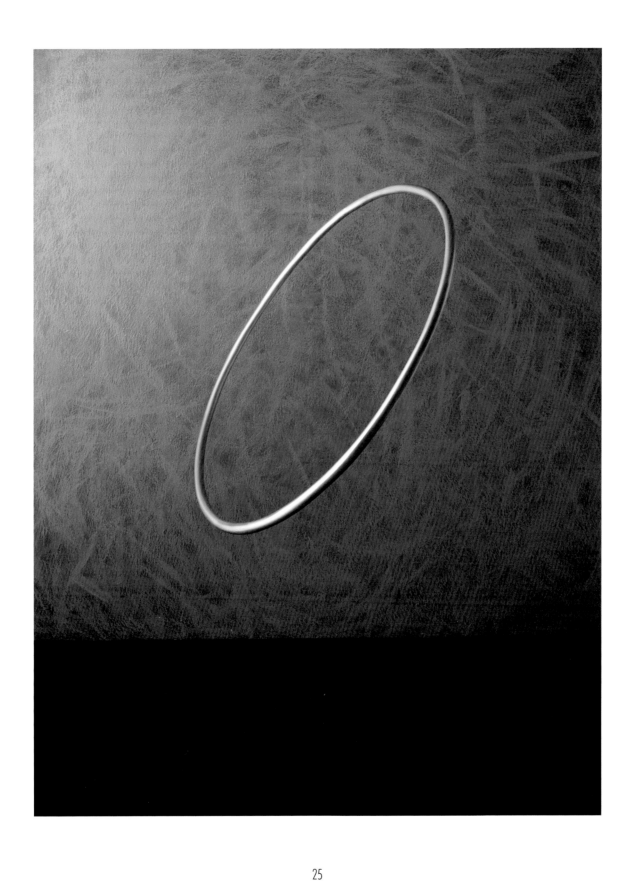

Vertical and Horizontal #19, 1990

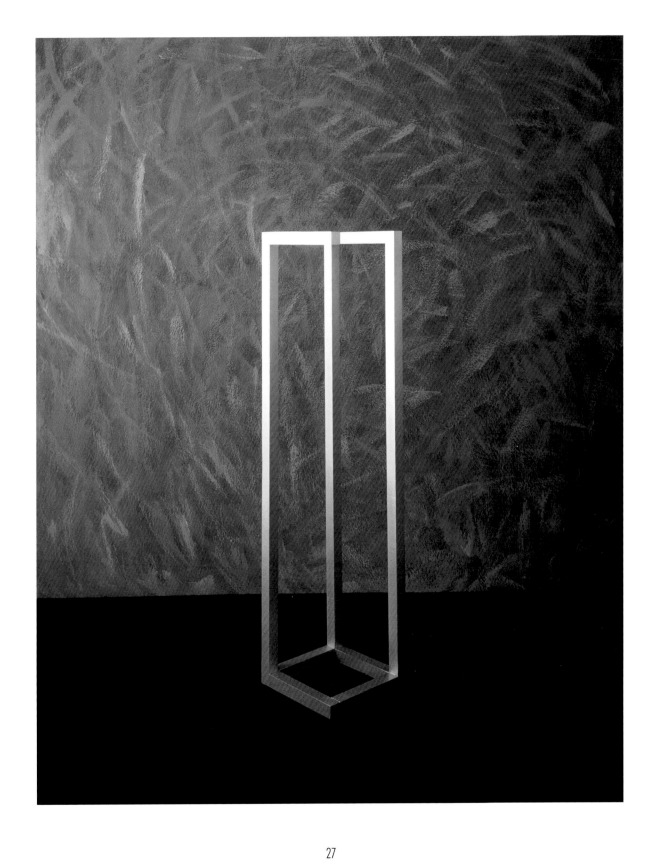

The Death of Father, 1991

Yasumasa Morimura

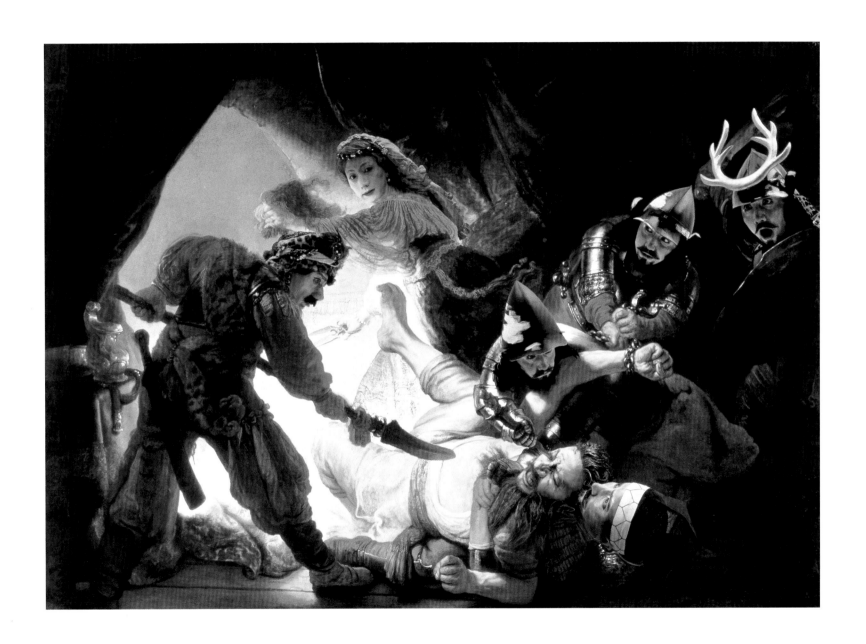

Six Brides, 1991

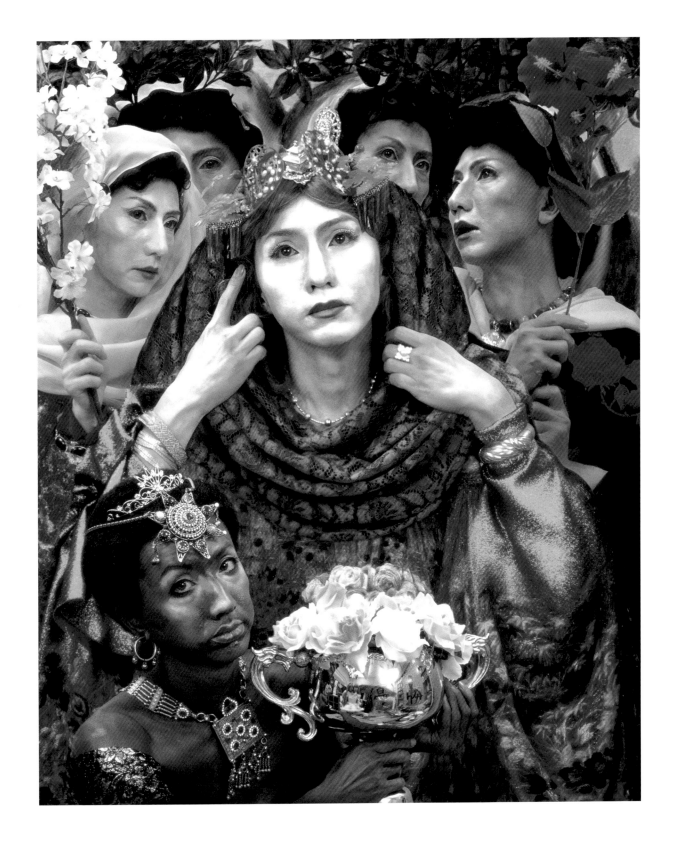

Doublonnage (Portrait B), 1988

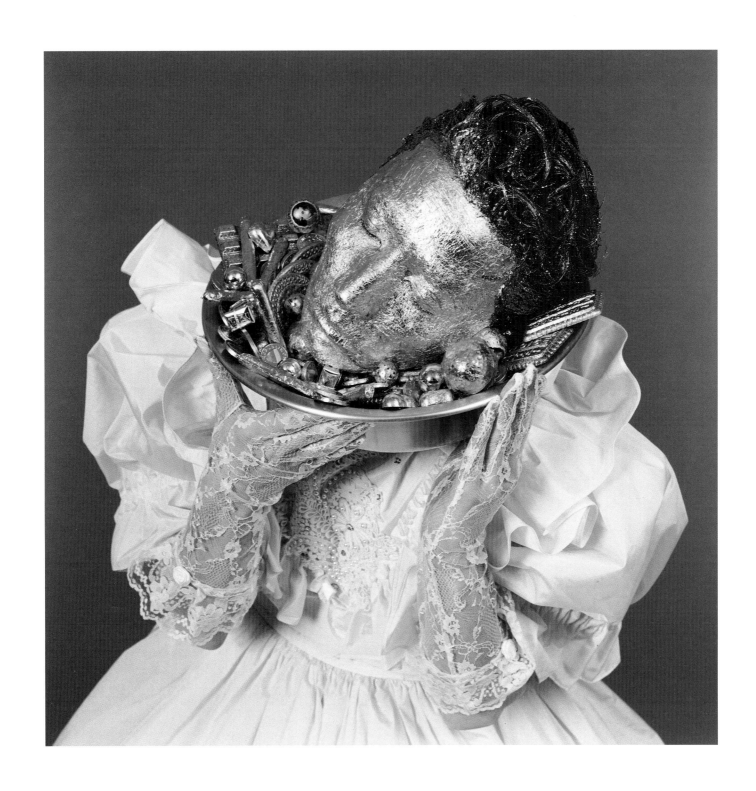

Miyagase, Kanagawa Prefecture, 1983

Toshio Shibata

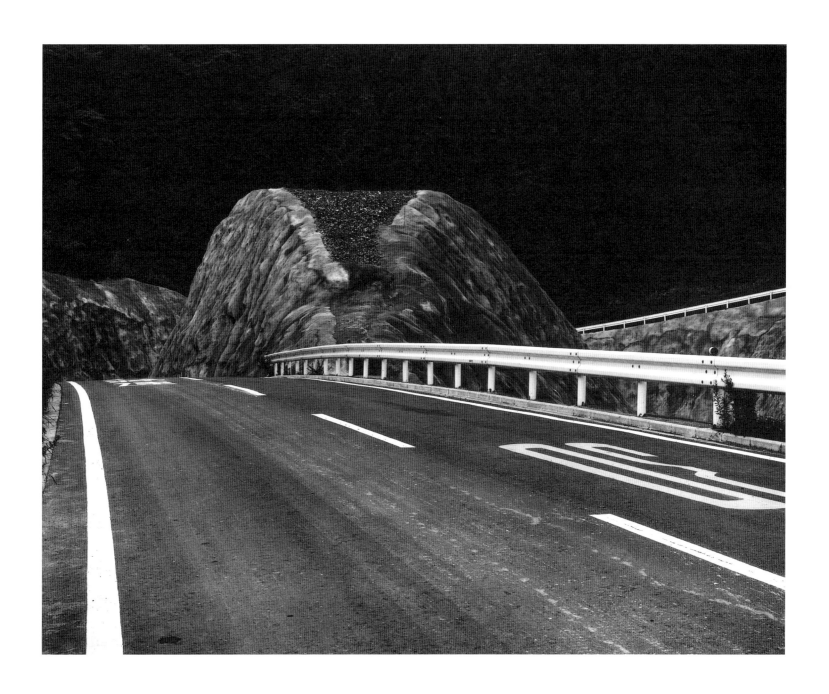

Yunotani Village, Niigata Prefecture, 1989

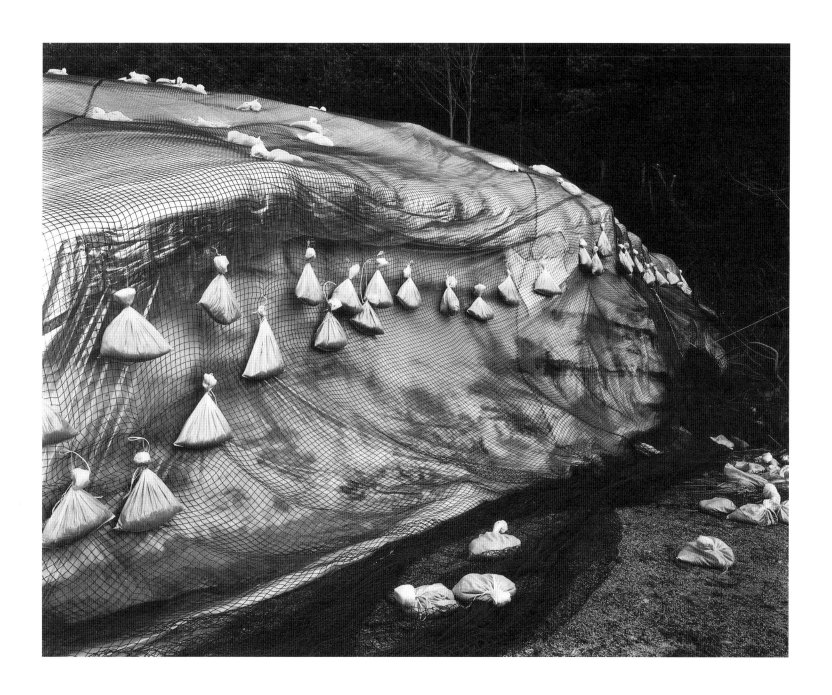

Sagara Village, Kumamoto Prefecture, 1989

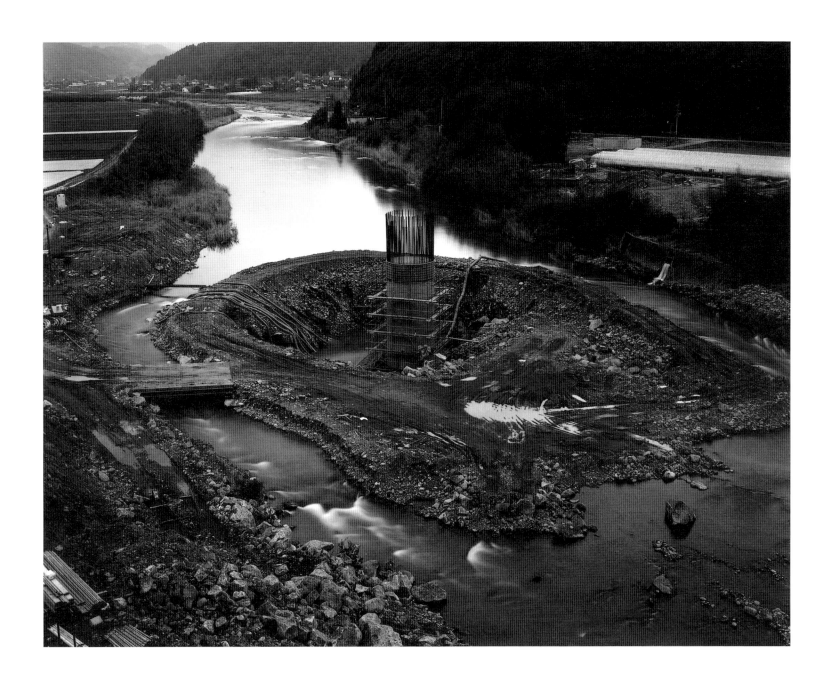

Shimogo Town, Fukushima Prefecture, 1990

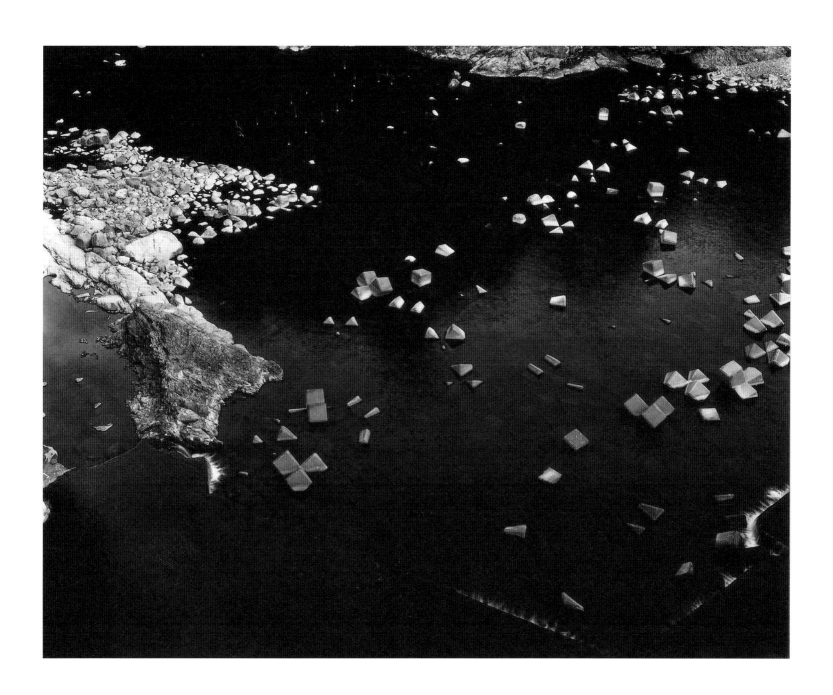

Tajima Town, Fukushima Prefecture, 1988

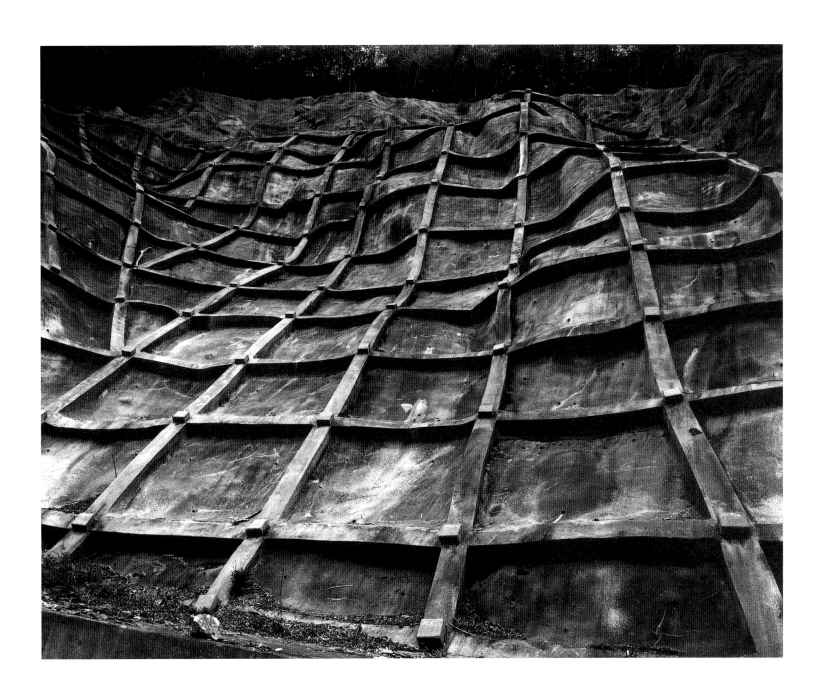

Tyrrhenian Sea, Positano, 1990

Hiroshi Sugimoto

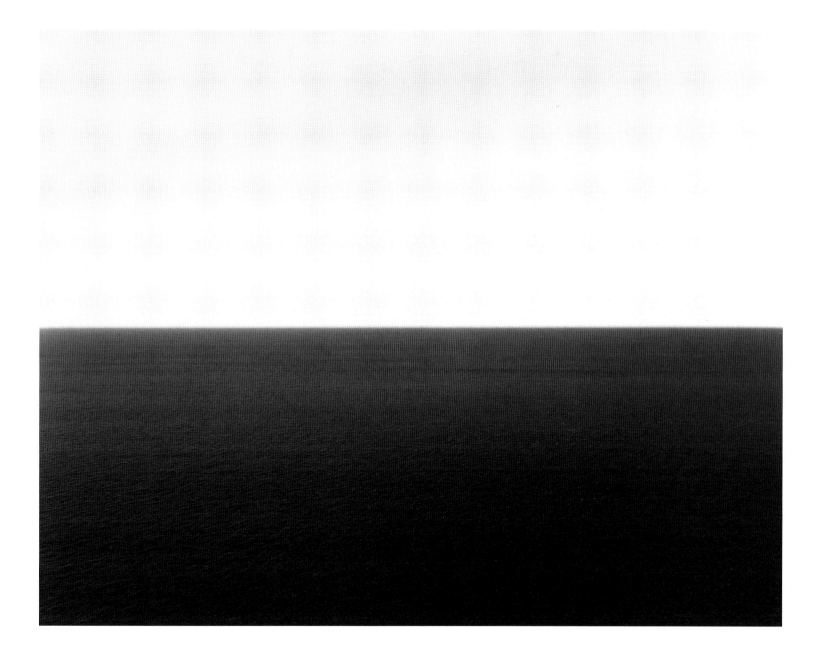

Ionian Sea, Santa Cesarea III, 1990

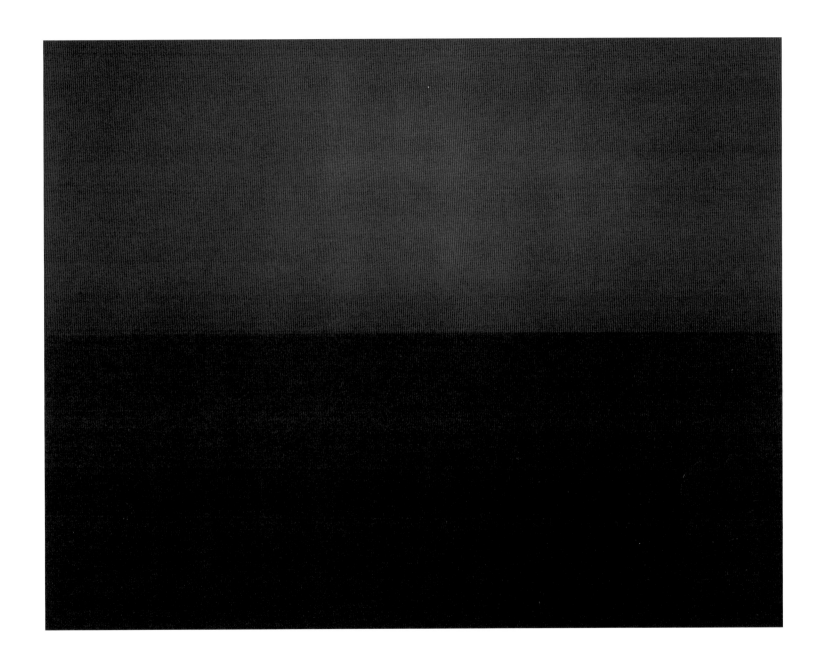

Sea of Galilee, Golan, 1992

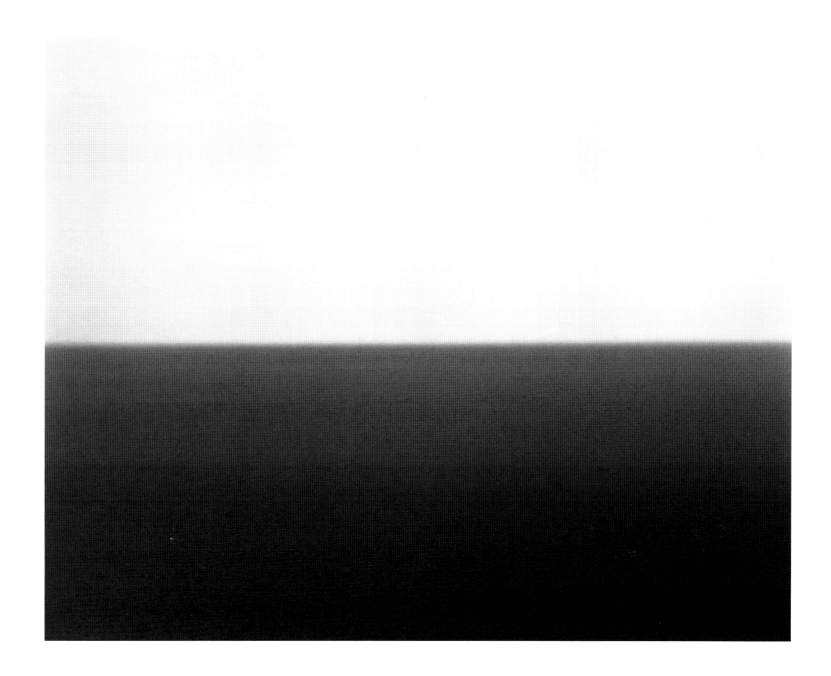

Sea of Japan, Oki I, 1987

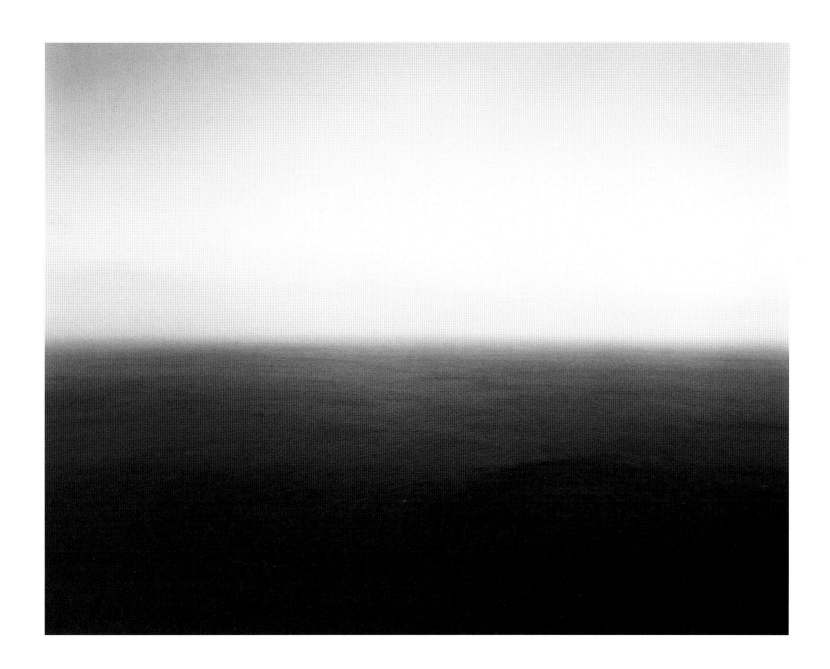

51

Marmar Sea, Silivli, 1991

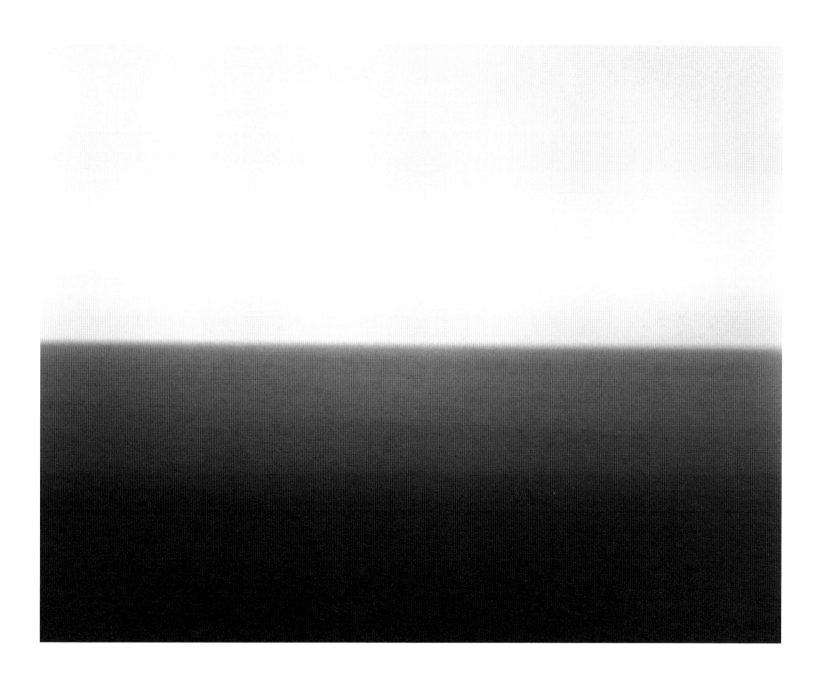

Exhibition Checklist

Miyako Ishiuchi
1947 No.9 Pub Manager
15 5/8 X 21 1/2" (39.6 X 54.6 cm)
Gelatin Silver Print
Lent by the Artist

1947 No.23 Painter
15 5/8 X 21 1/2" (39.6 X 54.6 cm)
Gelatin Silver Print
Lent by the Artist

1947 No.29 House Wife
15 5/8 X 21 1/2" (39.6 X 54.6 cm)
Gelatin Silver Print
Lent by the Artist

1947 No.37 Finance Company Employee
15 5/8 X 21 1/2" (39.6 X 54.6 cm)
Gelatin Silver Print
Lent by the Artist

1947 No.61 House Wife
15 5/8 X 21 1/2" (39.6 X 54.6 cm)
Gelatin Silver Print
Lent by the Artist

1947 No.7 Company Employee
15 5/8 X 21 1/2" (39.6 X 54.6 cm)
Gelatin Silver Print
Lent by the Artist

1947 No.30 House Wife
15 5/8 X 21 1/2" (39.6 X 54.6 cm)
Gelatin Silver Print
Lent by the Artist

1947 No.11 Beauty Salon Assistant
15 5/8 X 21 1/2" (39.6 X 54.6 cm)
Gelatin Silver Print
Lent by the Artist

1947 No.49 Association Member
15 5/8 X 21 1/2" (39.6 X 54.6 cm)
Gelatin Silver Print
Lent by the Artist

1947 No.60 Artist
15 5/8 X 21 1/2" (39.6 X 54.6 cm)
Gelatin Silver Print
Lent by the Artist

All photographs were made in 1988 and 1989.

Yasumasa Morimura
The Death of Father, 1991
94 1/2 X 126" (240 X 320 cm)
Type C Print
Courtesy of Luhring Augustine Gallery, New York

Six Brides, 1991
47 1/4 X 55 1/4" (120 X 140 cm)
Type C Print
Courtesy of Luhring Augustine Gallery, New York

Doublonnage (Portrait B), 1988
47 1/4 X 47 1/4" (120 X 120 cm)
Type C Print
Courtesy of Fay Gold Gallery, Atlanta

Ken Matsubara
Vertical and Horizontal # 10, 1990
70 X 46 3/4" (178 X 118.7 cm)
Type C Print
Courtesy of Jayne H. Baum Gallery, New York

Vertical and Horizontal # 15, 1990
70 X 46 3/4" (178 X 118.7 cm)
Type C Print
Courtesy of Jayne H. Baum Gallery, New York

Vertical and Horizontal # 19, 1990
70 X 46 3/4" (178 X 118.7 cm)
Type C Print
Courtesy of Jayne H. Baum Gallery, New York

Vertical and Horizontal # 14, 1990
70 X 46 3/4" (178 X 118.7 cm)
Type C Print
Courtesy of Jayne H. Baum Gallery, New York

Vertical and Horizontal # 16, 1990
70 X 46 3/4" (178 X 118.7 cm)
Type C Print
Courtesy of Jayne H. Baum Gallery, New York

Toshio Shibata
Miyagase, Kanagawa Prefecture, 1983
14 X 17 1/2" (35.6 X 44.5 cm)
Gelatin Silver Print
Courtesy of RAM, Santa Monica/Tokyo

Yunotani Village, Niigata Prefecture, 1989
17 1/2 X 22" (44.5 X 55.9 cm)
Gelatin Silver Print
Courtesy of RAM, Santa Monica/Tokyo

Sagara Village, Kumamoto Prefecture, 1990
17 1/2 X 22" (44.5 X 55.9 cm)
Gelatin Silver Print
Courtesy of RAM, Santa Monica/Tokyo

Shimogo Town, Fukushima Prefecture, 1990
17 1/2 X 22" (44.5 X 55.9 cm)
Gelatin Silver Print
Courtesy of RAM, Santa Monica/Tokyo

Tajima Town, Fukushima Prefecture, 1988
17 1/2 X 22" (44.5 X 55.9 cm)
Gelatin Silver Print
Courtesy of RAM, Santa Monica/Tokyo

Sagara Village, Kumamoto Prefecture, 1991
17 1/2 X 22" (44.5 X 55.9 cm)
Gelatin Silver Print
Courtesy of RAM, Santa Monica/Tokyo

Setana County, Hokkaido, 1988
17 1/2 X 22" (44.5 X 55.9 cm)
Gelatin Silver Print
Courtesy of RAM, Santa Monica/Tokyo

Shiiba Village, Miyazaki Prefecture, 1990
17 1/2 X 22" (44.5 X 55.9 cm)
Gelatin Silver Print
Courtesy of RAM, Santa Monica/Tokyo

Asahi Town, Hokkaido, 1988
17 1/2 X 22" (44.5 X 55.9 cm)
Gelatin Silver Print
Courtesy of RAM, Santa Monica/Tokyo

Saito City, Miyazaki Prefecture, 1990
17 1/2 X 22" (44.5 X 55.9 cm)
Gelatin Silver Print
Courtesy of RAM, Santa Monica/Tokyo

Hiroshi Sugimoto
Tyrrhenian Sea, Positano, 1990
16 1/2 X 21 1/4" (41.9 X 54 cm)
Gelatin Silver Print
Courtesy of Sonnabend Gallery, New York

Ionian Sea, Santa Cesarea III, 1990
16 1/2 X 21 1/4" (41.9 X 54 cm)
Gelatin Silver Print
Courtesy of Sonnabend Gallery, New York

Sea of Galilee, Golan, 1992
16 1/2 X 21 1/4" (41.9 X 54 cm)
Gelatin Silver Print
Courtesy of Sonnabend Gallery, New York

Sea of Japan, Oki I, 1987
16 1/2 X 21 1/4" (41.9 X 54 cm)
Gelatin Silver Print
Courtesy of Sonnabend Gallery, New York

Marmar Sea, Silivli, 1991
16 1/2 X 21 1/4" (41.9 X 54 cm)
Gelatin Silver Print
Courtesy of Sonnabend Gallery, New York

Artists Biographies

MIYAKO ISHIUCHI

1947 Born in Gumma, Japan

EDUCATION

1970 Leaves Textile Department of Tama Art University; majored in weaving

SELECTED SOLO EXHIBITIONS

1994 *To the Skin*, Gallery Te, Tokyo, Japan
1947, Laurence Miller Gallery, New York City
1993 *Interior 3*, Gallery Te, Tokyo, Japan
1991 *Interior*, Past Rays Yokohama Photo Gallery, Yokohama, Japan
1988 *From Yokosuka Third Position*, Room 801, Tokyo, Japan
1984 T*okyo Bay Cities*, Nikon Salon Ginza, Tokyo, Japan
1980 *Endless Night*, Nikon Salon Ginza, Tokyo, Japan
1978 *Apartment*, Nikon Salon Ginza, Tokyo, Japan
1977 *Yokosuka Story*, Nikon Salon Ginza, Tokyo, Japan

SELECTED GROUP EXHIBITIONS

1994 *Inside Out: Contemporary Japanese Photography*, The Light Factory Photographic Arts Center, Charlotte, North Carolina
Japanese Art After 1945, The Guggenheim Museum Soho, New York City
When the Body Becomes Art, Itabashi Art Museum, Tokyo, Japan
1993 *Zeitgenössische Japanische Photographie*, Kunsthaus, Zürich, Switzerland
1991 *Japanese Contemporary Photography*, The Photographer's Gallery, London, England
Self-Portraits of Contemporary Women, Tokyo Metropolitan Museum of Photography, Japan
1989 *Contemporary Japanese Photography*, Center for Creative Photography, University of Arizona, Tucson.
1985 *Paris/New York/Tokyo*, Tsukuba Photography Museum, Tsukuba, Japan
1984 *Dumont'5 - Die Japanische Photographie*, Museum Für kunst und Gerwerbe, Hamburg, Germany
1979 *Japan: A Self-Portrait*, International Center for Photography, New York City

SELECTED PUBLIC COLLECTIONS

Center for Creative Photography, University of Arizona, Tucson

Tokyo Metropolitan Museum of Photography, Japan
The Museum of Art Yokohama, Japan
The National Museum of Modern Art Tokyo, Japan
Kunsthaus Zürich, Switzerland

SELECTED BIBLIOGRAPHY

1978 *Apartment*, Shasin Tsushinsha
1979 *Tokosuka Story*, Shasin Tsushinsha
1981 *Endless Night*, Asahi Sonorama
Tokyo Dental College, Issei Shuppan
1990 *1 9 4 7*, Inter Press Corporation
1993 *Monochrome*, Chikuma Shobo
1994 *1906 to the skin*, Kawade Shobo Sinsha Publishers

KEN MATSUBARA

1949 Born in Tokyo, Japan

EDUCATION

1973 Musashino Art University, Tokyo, Japan, diploma

SELECTED SOLO EXHIBITIONS

1993 Center for Photography, Woodstock, New York
Hosomi Gallery, Tokyo, Japan
1992 Jayne H. Baum Gallery, New York City
PS Gallery, Tokyo, Japan
1988 Picture Photo Space, Osaka, Japan
Jayne H. Baum Gallery, New York City
1987 Light Gallery, New York City
Studio 666, Paris, France
Polaroid Gallery, Tokyo, Japan
1982 Kamakura Gallery, Tokyo, Japan
Suikato Gallery, Tokyo, Japan
1981 Axis Gallery, Tokyo, Japan

SELECTED GROUP EXHIBITIONS

1994 *Inside Out: Contemporary Japanese Photography*, The Light Factory Photographic Arts Center, Charlotte, North Carolina
1993 *Breda Fotographica '93*, The DeBeyerd, Breda, The Netherlands
1992 *Photography in Contemporary Art*, Walker Hill Art Center, Seoul, Korea
1991 *The 20th Contemporary Art Exhibition of Japan*, Tokyo Metropolitan Museum of Fine Art, Tokyo, Japan
Image Transfer, Polaroid Gallery, Tokyo, Japan

1990 *The Imprinted Ideas*, Tochigi Prefectural Museum of Fine Arts, Tochigi, Japan
The Silent Dialogue: Still Life in The West and Japan, Shizuoka l'refectural Museum of Art, Shizuoka, Japan
1981 *Photography and Fringe Expressions II*, Miyazaki Gallery, Osaka, Japan

SELECTED COLLECTIONS

Bayly Art Museum, Charlottesville, Virginia
International Polaroid Collection, Cambridge, Massachusetts
La Bibliotheque de Villeurbanne, Lyon, France
Maison du Livre de L'image et du Son, Cedex, France
Museum of Fine Arts, Houston, Texas
Reader's Digest, New York City
Tokyo Metropolitan Museum of Fine Art

SELECTED BIBLIOGRAPHY

1993 Coleman, A.D., "Ken Matsubara: Dramas of the Inanimate," *The World & I*, October, pp. 144 - 149.
Coleman, A.D., "Letter From Breda," no. 46, *Photo Metro*, October, vol. 11, Issue 112, pp. 26 - 27.
1992 Coleman, A.D., "The East comes West: Japanese Photography in the U.S. Today," *Camera and Darkroom*, June, pp. 18 - 19, 25.
1990 Yamamoto, Kazuhiro, "Ken Matsubara: Gazing at Still Life Held Still," *Ken Matsubara, Vertical and Horizontal*, (exhibition catalog) published by PS Gallery, Tokyo, Japan.
Iizawa, Kohtaro, *Displacements and Repetitions*, (exhibition catalog) PS Gallery, Tokyo, Japan.
1987 Shinoda, Tatsumi, "Ken Matsubara Polaroid Art," in *Mimesis of the Media*, published by Nippon Polaroid K.K.

YASUMASA MORIMURA

1951 Born in Osaka, Japan

EDUCATION

1978 Kyoto City University of Art

SELECTED SOLO EXHIBITIONS

1994 The Power Plant, Toronto, Canada

(Morimura cont.)

1992 Tate Gallery, London, England
 Options 44: Yasumasa Morimura, Museum of
 Contemporary Art, Chicago, Illinois
 The Carnegie Museum of Art, Pittsburgh, Pennsylvania
1991 Luhring Augustine, New York City
1990 Nicola Jacobs Gallery, London, England
 Daughter of Art History, Sagacho Exhibit Space,
 Tokyo, Japan
1989 *Criticism and the Lover*, Mohly Gallery, Osaka, Japan
1986 *Mon amour violet et autres*, Gallery Haku, Osaka, Japan

SELECTED GROUP EXHIBITIONS

1994 *Inside Out: Contemporary Japanese Photography*, The
 Light Factory Photographic Arts Center, Charlotte,
 North Carolina
1994 *From Beyond the Pale*, Irish Museum of Modern Art,
 Dublin, Ireland
1993 *Dress Codes*, Institute of Contemporary Art, Boston,
 Massachusetts
 Slittamenti, Aperto '93, Venice Biennale, Venice, Italy
1992 *A Cabinet of Signs*, Whitechapel Art Gallery, London,
 England
 Post-Human, Musee d'art Contemporain Pully/Lausanne,
 Switzerland. Traveled to:Castello di Rivoli, Turin,
 Italy; Deste Foundation for Contemporary Art,
 Athens, Greece; Deichtorhallen Hamburg, West
 Germany
1990 *Japan Art Today - Elusive Perspective/Changing Visions*,
 The Cultural Centre of Stockholm, Sweden.
 Traveled to: The Exhibition Hall Charlottenborg,
 Copenhagen, Denmark; The Helsinki Municipal
 Museum, Finland; The Reykjavik Municipal
 Museum, Iceland
1989 *Against Nature: Japanese Art in the Eighties*, co-organized
 by Grey Art Gallery, New York University and List
 Visual Art Center, MIT, Cambridge, Massachusetts.
 Traveled to: San Francisco Museum of Modern Art,
 California; Akron Art Museum, Ohio; List Visual Art
 Center, MIT; Seattle Art Museum, Washington; The
 Contemporary Arts Center, Cincinnati, Ohio; Grey
 Art Gallery, New York University; and Contemporary
 Arts Museum, Houston, Texas.
1987 *Yes Art Deluxe*, Sagacho Exhibit Space, Tokyo, Japan

SELECTED PUBLIC COLLECTIONS

Carnegie Museum of Art, Pittsburg
Museum of Fine Arts, Boston
Denver Art Museum

SELECTED BIBLIOGRAPHY

1994 Bryson, Norman. "Mother (Judith II)," Artforum, *January*
 1994. pp. 70 - 71.
1993 Baker, Kenneth. "When clothes don't make the man."
 San Francisco Chronicle. May 24, 1993.
 Drucker, Johanna. "Simulation/Spectacle: Beyond the
 Boundaries of the Old Avant Guarde and
 Exhausted Modernism," *Third Text*, Summer. pp. 3 - 16.
 Dougherty, William. "ICA's 'Dress Codes' : Where Guys
 Are Dolls." *Harvard Crimson*, April 8, 1993.
1992 Friis-Hansen, Dana. "Miran Fukuda and Yasumasa
 Morimura. *Flash Art*, Summer. p. 128.
 Hagen, Charles. "Yasumasa Morimura at Luhring
 Augustine." , November 29, 1992. p. C26.
 Plagens, Peter. "The Great Impersonator." *Newsweek*,
 April 6, 1992. pp. 62 - 63.
 Zimmer, William. "Appropriation: When Borrowing from
 Earlier Artists is Irresistible." *The New York Times*,
 Sunday, June 14, 1992. A&L 22.
1991 Levin, Kim. "Voice Choices: Yasumasa Morimura." *Village*
 Voice, December 10, 1991.
1990 Brenson, Michael. "When self-consciousness became
 king." *The New York Times*, February 18, 1990.
 p. 35.
 Heartney, Eleanor. "Mixed Messages." *Art in America*,
 April 1990. pp. 213 - 128.

TOSHIO SHIBATA

1949 Born in Tokyo, Japan

EDUCATION

1972 B.A., Tokyo University of Fine Art and Music, Japan
1974 M.F.A., Tokyo University of Fine Art and Music, Japan

SELECTED SOLO EXHIBITIONS

1993 Plaza Gallery, Tokyo, Japan
 Past Rays, Yokohama City, Japan
 The Art Institute of Chicago, Illinois
 Laurence Miller Gallery, New York City
1992 Il tempo, Tokyo, Japan
1991 Kawasaki City Museum, Kawasaki City, Japan
 Photo Interform & Interform Atelier, Osaka City, Japan
1988 Zeit Foto Salon, Tokyo, Japan
1984 Zeit Foto Salon, Tokyo, Japan
1979 Nikon Salon, Tokyo, Japan

SELECTED GROUP EXHIBITIONS

1994 *Inside Out: Contemporary Japanese Photography*, The
 Light Factory Photographic Arts Center, Charlotte,
 North Carolina
 Liquid Crystal Futures, The Fruitmarket Gallery, Edinburgh,
 Scotland
1993 *Japanese Contemporary Photography*, Kunsthaus Zürich,
 Switzerland
1992 *New Photography 8*, The Museum of Modern Art, New
 York City
1991 *Artists who love nature*, Meguro Museum of Art, Tokyo,
 Japan
1990 *The Past and the Present of Photography*, The National
 Museum of Modern Art, Tokyo, Japan Traveled to:
 The National Museum of Modern Art, Kyoto
 Japanese Contemporary Photography, Tokyo Metropolitan
 Museum of Photography, Japan Traveled to:
 Pavillon des Arts, Paris, France
1989 *The Hitachi Collection of Contemporary Japanese
 Photography*, Center for Creative Photography,
 University of Arizona, Tucson.
1986 *Fotographia Japanesa Contemporanea*, Casa Elizalde,
 Barcelona, Spain
1985 *Dumont Foto 5*; Die Japanische Photographie Museum für
 Kunst und Gewebe, Hamburg, West Germany

SELECTED PUBLIC COLLECTIONS

Museum für Kunst und Gewerbe, Hamburg, West
 Germany
Yokohama Museum of Art, Yokohama, Japan
Bibliothéque National, Paris, France
The National Museum of Modern Art, Tokyo, Japan
The Los Angeles Museum of Art, California
The Museum of Modern Art, New York City
The Metropolitan Museum of Art, New York City
The Art Institute of Chicago, Illinois

SELECTED BIBLIOGRAPHY

1994 *Liquid Crystal Futures: Contemporary Japanese
 Photography*, (exhibition catalog) The Fruitmarket
 Gallery, Edinburgh, Scotland.
1993 Kuspit, Donald, "Toshio Shibata at Laurence Miller
 Gallery," *Art Forum*, April 1993.
1992 Enyeart, James, *PHOTOGRAPHS by Toshio Shibata* (Tokyo:
 Asahi Shimbun Publishing Co., 1992).
1990 *The Past and the Present of Photography*, (exhibition cat-
 alog) The National Museum of Modern Art, Tokyo.

HIROSHI SUGIMOTO

1948 Born in Tokyo, Japan
 Lives and works in New York City

EDUCATION
1970 B.A., Saint Paul's University, Tokyo
1972 B.F.A., Art Center College of Design, Los Angeles

SELECTED SOLO EXHIBITIONS
1994 Sonnabend Gallery, New York
1993 Palais des Beaux Arts, Charleroi, Belgium
 Seascapes, Theatres, Dioramas & Drive-Ins, White Cube,
 London, England
 Virginia Museum of Fine Arts, Richmond
 The Museum of Contemporary Art, Los Angeles, California
1992 Sonnabend Gallery, New York
 Time Exposed, CAPC, Mussee d'Art Contemporain,
 Bordeaux, France
1991 Sagascho Exhibit Space and IBM Courtyard, Tokyo, Japan
1990 St. Louis Art Museum, Missouri
1989 The National Museum of Contemporary Art, Osaka, Japan
 The Cleveland Museum of Art, Ohio

SELECTED GROUP EXHIBITIONS
1994 *Inside Out: Contemporary Japanese Photography*, The
 Light Factory Photographic Arts Center, Charlotte,
 North Carolina
1993 *A Century of Silence*, University Art Museum, SUNY
 Binghamton, New York
 *Multiple Images: Photographs Since 1965 from the
 Collection*, Museum of Modern Art, New York
1991 *Beyond Japan: A Photo Theater*, Barbican Art Gallery,
 London, England
 Carnegie International 1991, The Carnegie Museum of
 Art, Pittsburg, Pennsylvania
1990 *Natural History Recreated*, The Center for Photography,
 Woodstock, New York
 Photography Past and Present, National Museum of
 Modern Art, Tokyo and Kyoto National Museum of
 Modern Art, Japan
1989 Institute for Contemporary Art, Philadelphia, Pennsylvania
1985 *The Art of Memory/The Loss of History*, The New
 Museum of Contemporary Art, New York

SELECTED PUBLIC COLLECTIONS
The Metropolitan Museum of Art, New York
The Museum of Modern Art, New York
The Art Institute of Chicago, Illinois
National Gallery of Victoria, Melbourne, Australia
The Museum of Fine Arts, Boston, Massachusetts
National Museum of Modern Art, Tokyo, Japan
Hara Museum of Art, Tokyo, Japan
Fondation Cartier pour l'art contemporain, Jouy-en-Josas,
 France

SELECTED BIBLIOGRAPHY
1993 Brougher, Kerry. *Hiroshi Sugimoto: Memories in Black
 and White*, exhibition catalog (Los Angeles:
 Museum of Contemporary Art).
 Pagel, David. "Hiroshi Sugimoto: Angles Gallery,"
 Artforum, April XXXI, No. 8: pp. 102 - 103.
1992 Aletti, Vince. "Hiroshi Sugimoto," *The Village Voice*,
 March 3: p. 70.
 Baker, Kenneth. "Now Playing: Movie Theatre Photos,"
 San Francisco Chronicle, April 18.
1991 Kimmelman, Michael. "At Carnegie 1991, Sincerity Edges
 out Irony," *The New York Times*, Sunday, October
 27: pp. 31; 34.
1990 Cooke, Lynn. "Reorienting: Looking East," *Third Eye
 Center*, Glasgow, Scotland.
1989 Sozanski, Edward, J. "ICA 'Investigations': Work by three
 artists," *The Philadelphia Inquirer*, June 22.
 Marincola, Paula. "Investigations," *Contemporanea*,
 October: p. 92.

Selected Bibliography

Brougher, Kerry. "Hiroshi Sugimoto: Memories in Black and White," in *Sugimoto* (Los Angeles: The Museum of Contemporary Art, 1993)

Coleman, A.D. "The East Comes West: Japanese Photography in the United States Today," in *Camera and Darkroom*, June 1992: pp. 19 - 22.

Crimp, Douglas and Paula Marincola. *Image Scavengers: Photography* (Philadelphia: Institute of Contemporary Art, 1982).

Enyeart, James. "Traces of Splendor and Destiny," in PHOTOGRAPHS by Toshio Shibata (Tokyo: Asahi Shimbun Publishing Co., 1992)

Fox, Howard and Toshio Hara. *A Primal Spirit: Ten Contemporary Japanese Sculptors* (Los Angeles: The Los Angeles County Museum of Art, 1990).

Friedman, Martin, et.al., *Tokyo: Form and Spirit*, exhibition catalog (Minneapolis: The Walker Art Center and Harry N. Abrams, Inc., 1986).

Greenough, Sarah, et.al. *On the Art of Fixing A Shadow: 150 Years of Photography* (Washington, D.C.: The National Gallery of Art and Little, Brownand Company, Inc., 1989).

Halbreich, Kathy, et.al. *Against Nature: Japanese Art in the Eighties* (New York: Grey Art Gallery & Study Center, New York University, the MIT List Visual Arts Center and The Japan Foundation, 1989).

_____. *Culture and Commentary: An Eighties Perspective*, exhibition catalog (Washington, D.C.: Hirshhorn Museum and Sculpture Garden, 1990).

Hoy, Anne H. *Fabrications: Staged, Altered and Appropriated Photographs* (New York, 1987).

Imafuku, Ryuta and Michiko Kasahara. *Border/Borderless: Japanese Contemporary Photography* (Tokyo: Tokyo Metropolitan Museum of Photography, 1993).

Ishiuchi, Miyako, et. al., *1 • 9 • 4 • 7* (Tokyo: IPC Inter Press Corporation, 1990).

Jenkins, William. *New Topographics: Photographs of a Man-Altered Landscape* (Rochester, 1975).

Kasahara, Michiko. "Michiko Kon," in *Michiko Kon: Still Lives* (Cambridge: MIT List Visual Art Center, 1992).

McEvilley, Thomas. *Art & Otherness: Crisis in Cultural Identity* (New York: McPherson & Company Publishers, 1992).

Sussman, Elizabeth, Homi K. Bhabha, et.al., *1993 Biennial Exhibition*, exhibition catalog (New York: Whitney Museum of American Art and Harry N. Abrams, Inc., 1993).

Szarkowski, John and Shoji Yamagishi. *New Japanese Photography* (New York: The Museum of Modern Art, 1974).

Weinberg, Adam D., et.al. *Cross-References: Sculpture into Photography* (Minneapolis: The Walker Art Center, 1987).

Wright, Beryl J. "Yasumasa Morimura," in *Options 44: Yasumasa Morimura* (Chicago: Museum of Contemporary Art, 1992).

Yamamoto, Kazuhiro. "Ken Matsubara: Gazing at Life Held Still," in *Ken Matsubara: Vertical and Horizontal* exhibition catalog (Tokyo: PS Gallery, 1990).

Yokoe, Fuminori. *Japanese Photography in the 1970s* (Tokyo: Tokyo Metropolitan Museum of Photography, 1991).